SONNET
visual poetry
by widarto adi

SONNET
visual poetry
by Widarto Adi

Copyright 2012, Widarto Adi
All rights Reserved. No Part of this book may be reproduced or utilized
in any form or by any means, electronic or mechanical, including photocopying,
recording, or by any information storage and retrieval system,
without permision in writing from the publisher.

ISBN-13: 978-1489503480
ISBN-10: 148950348X

pink
white
blue

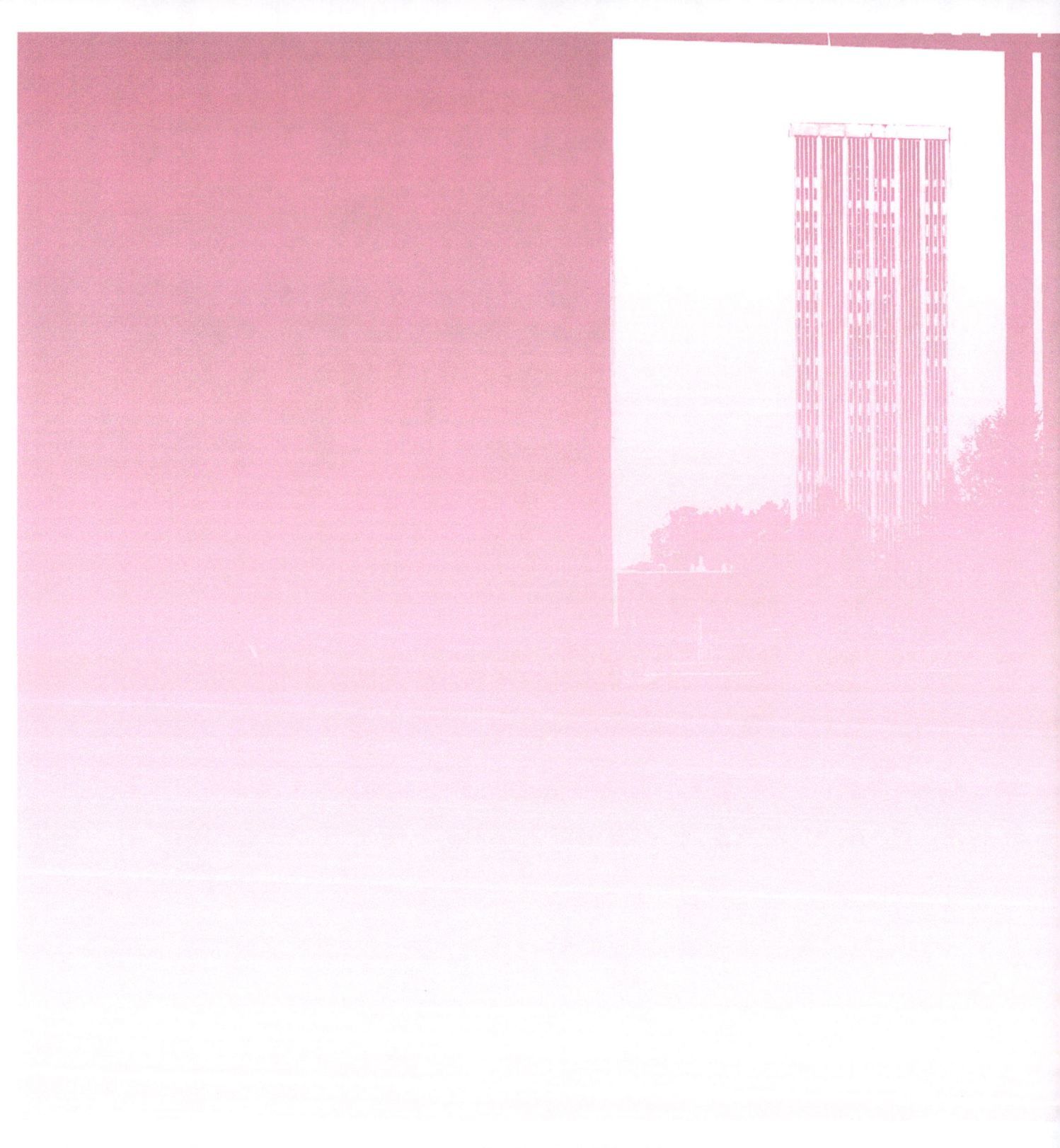

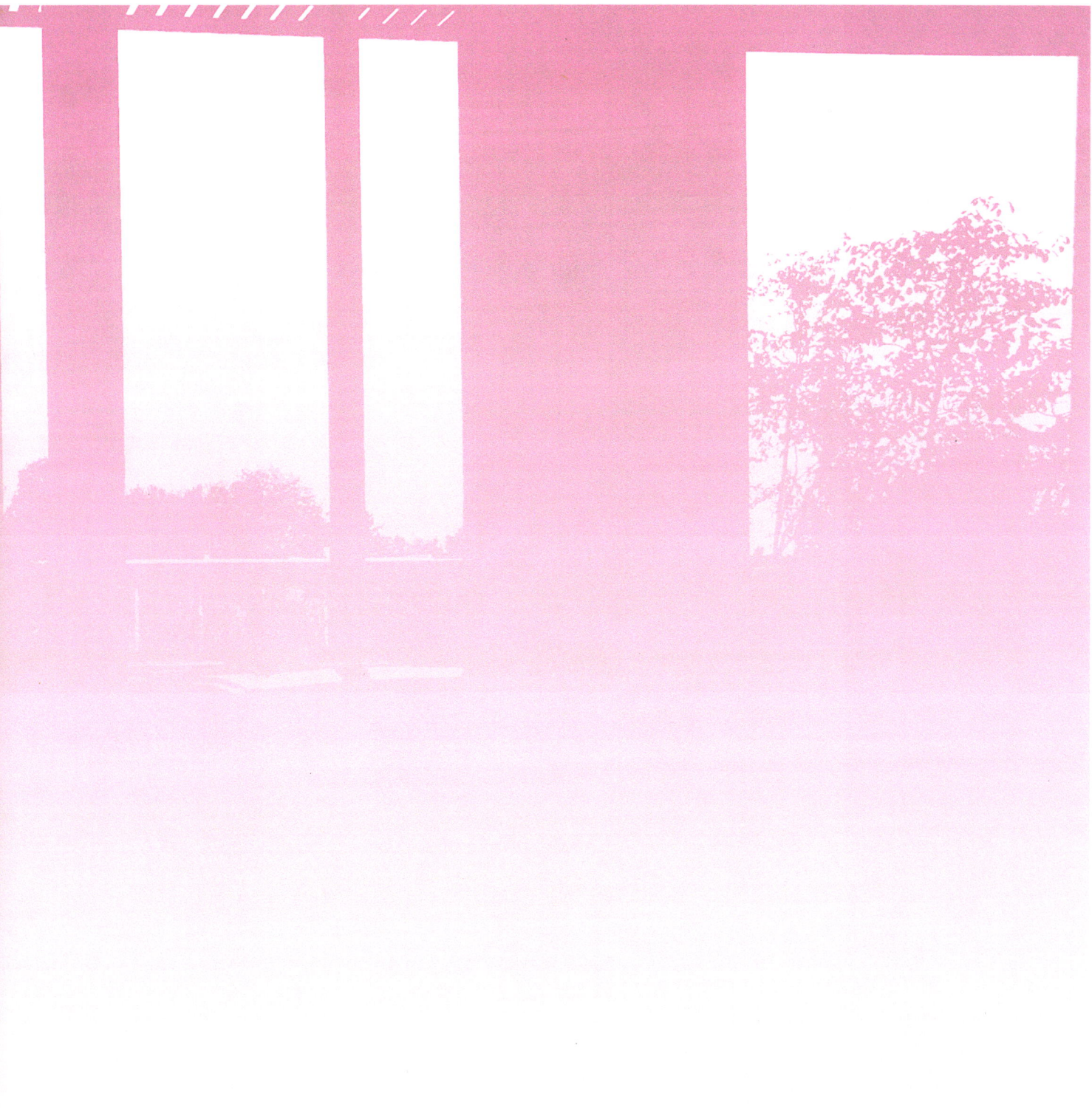

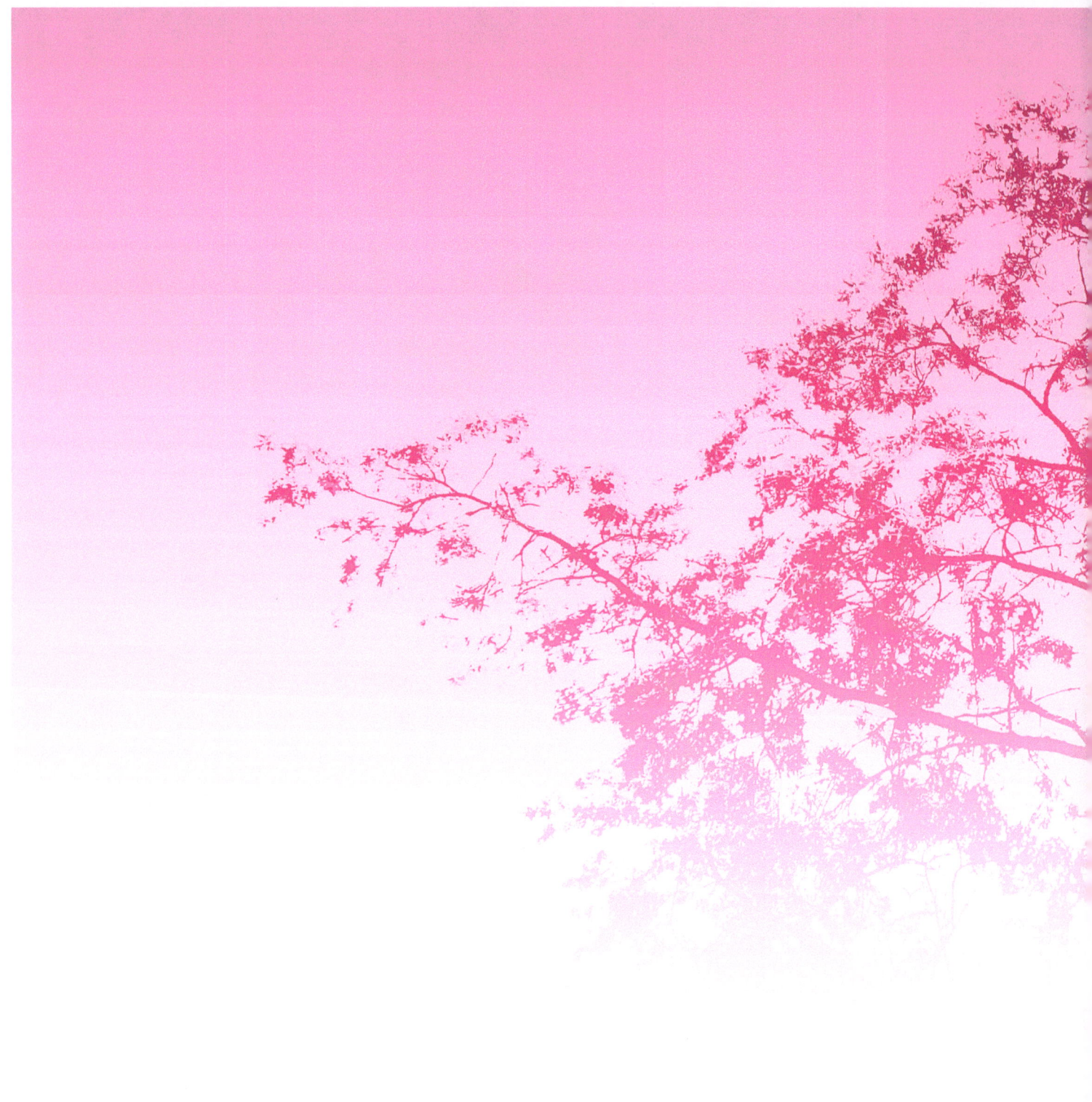

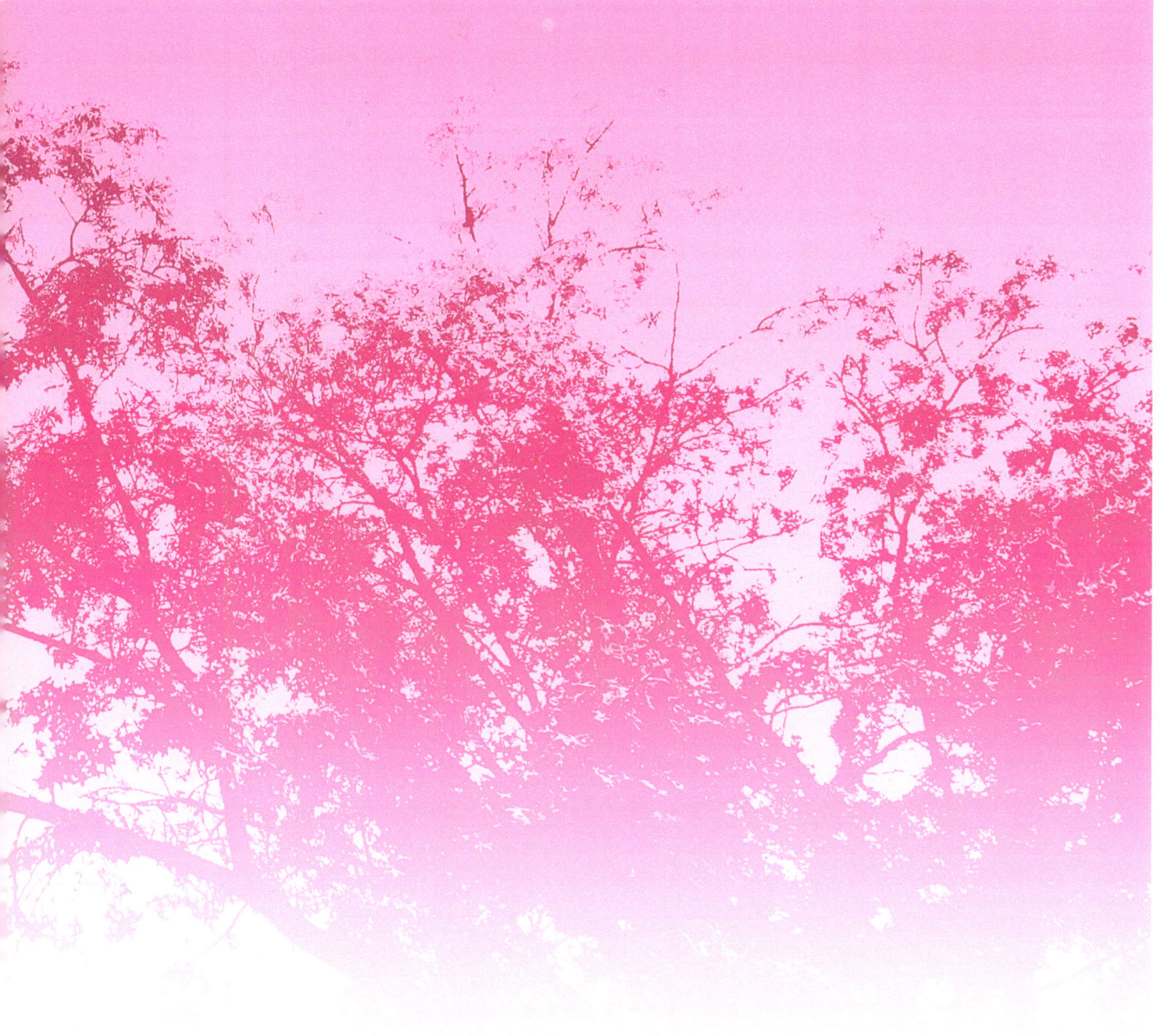

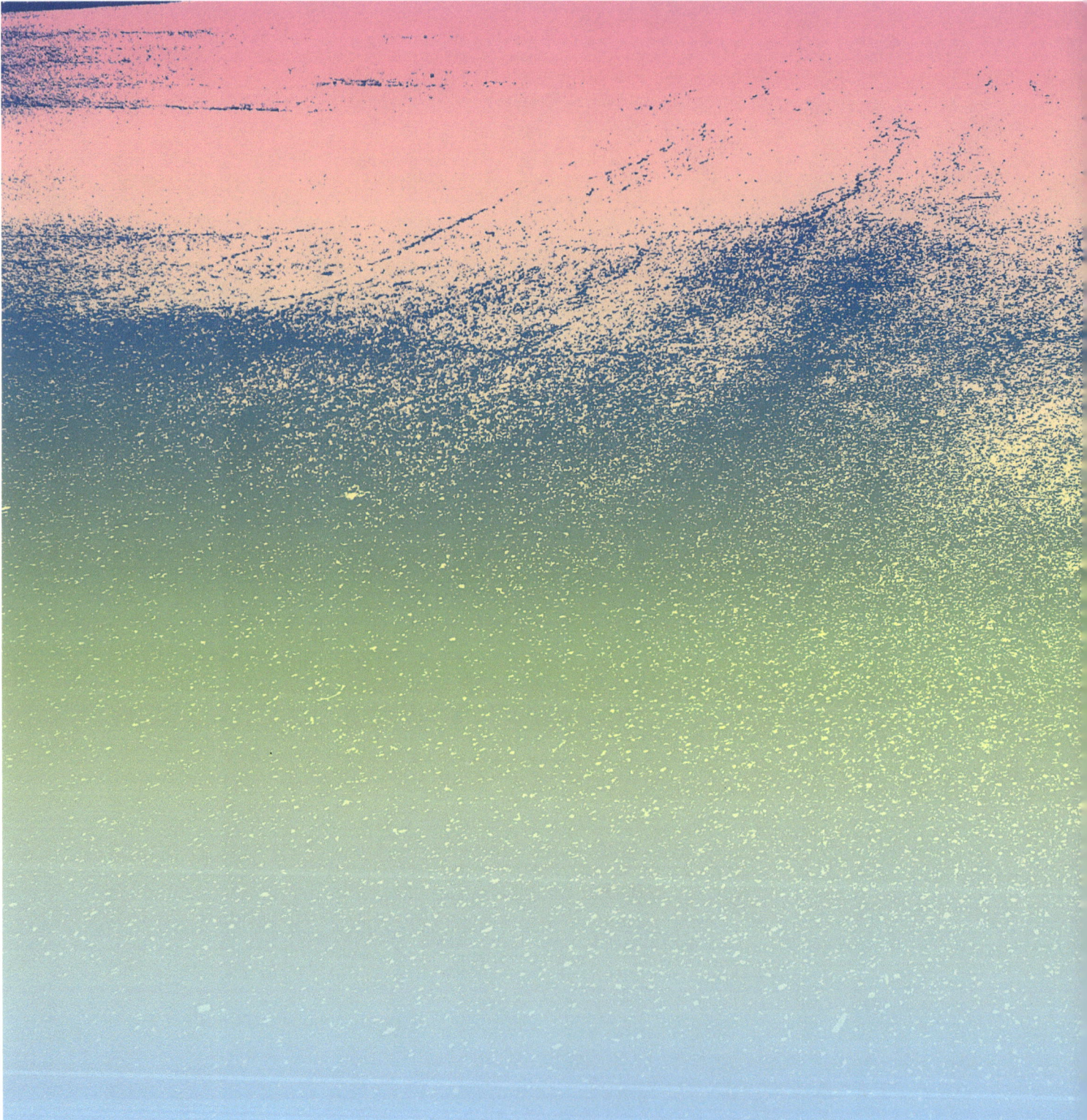

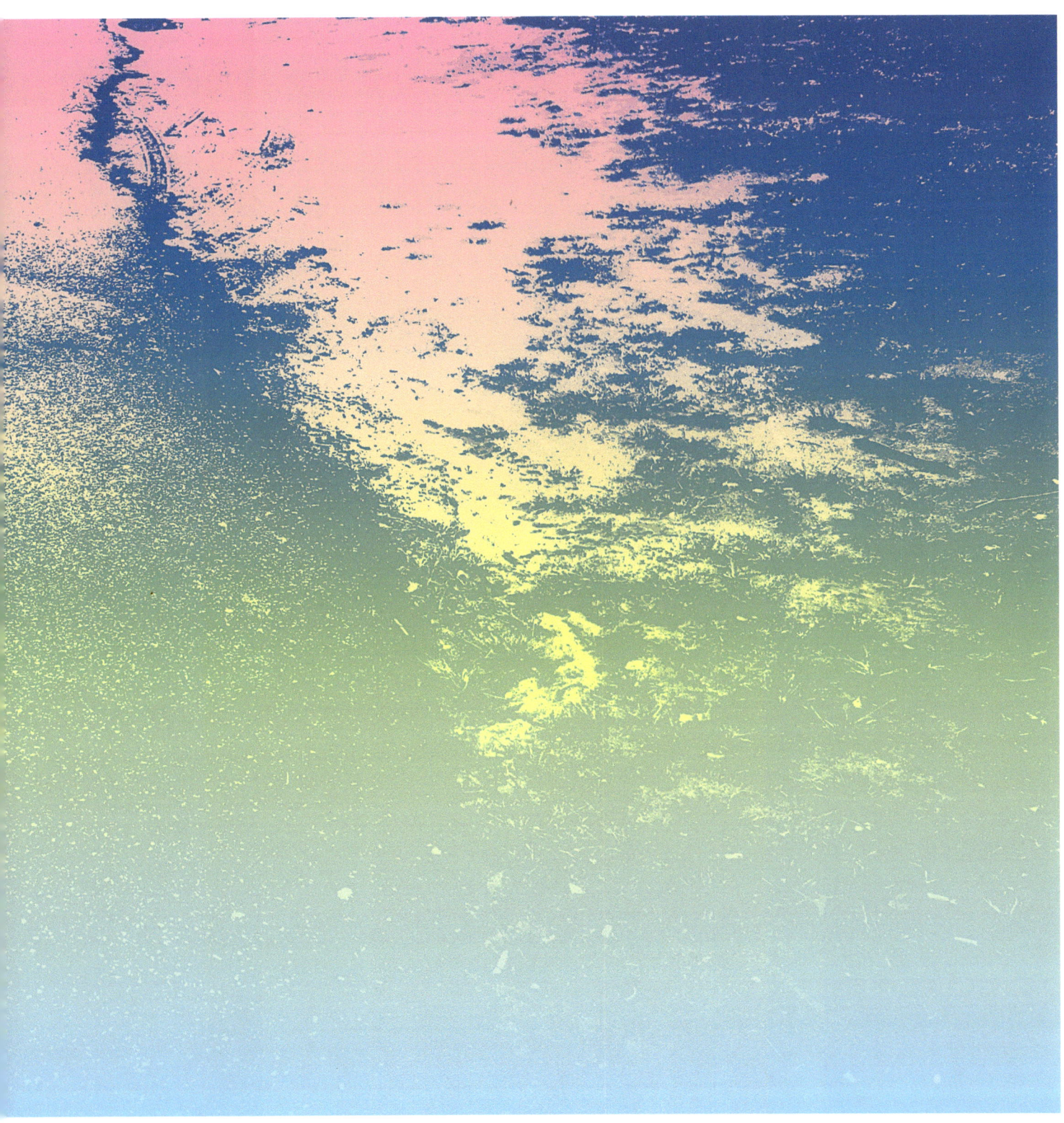

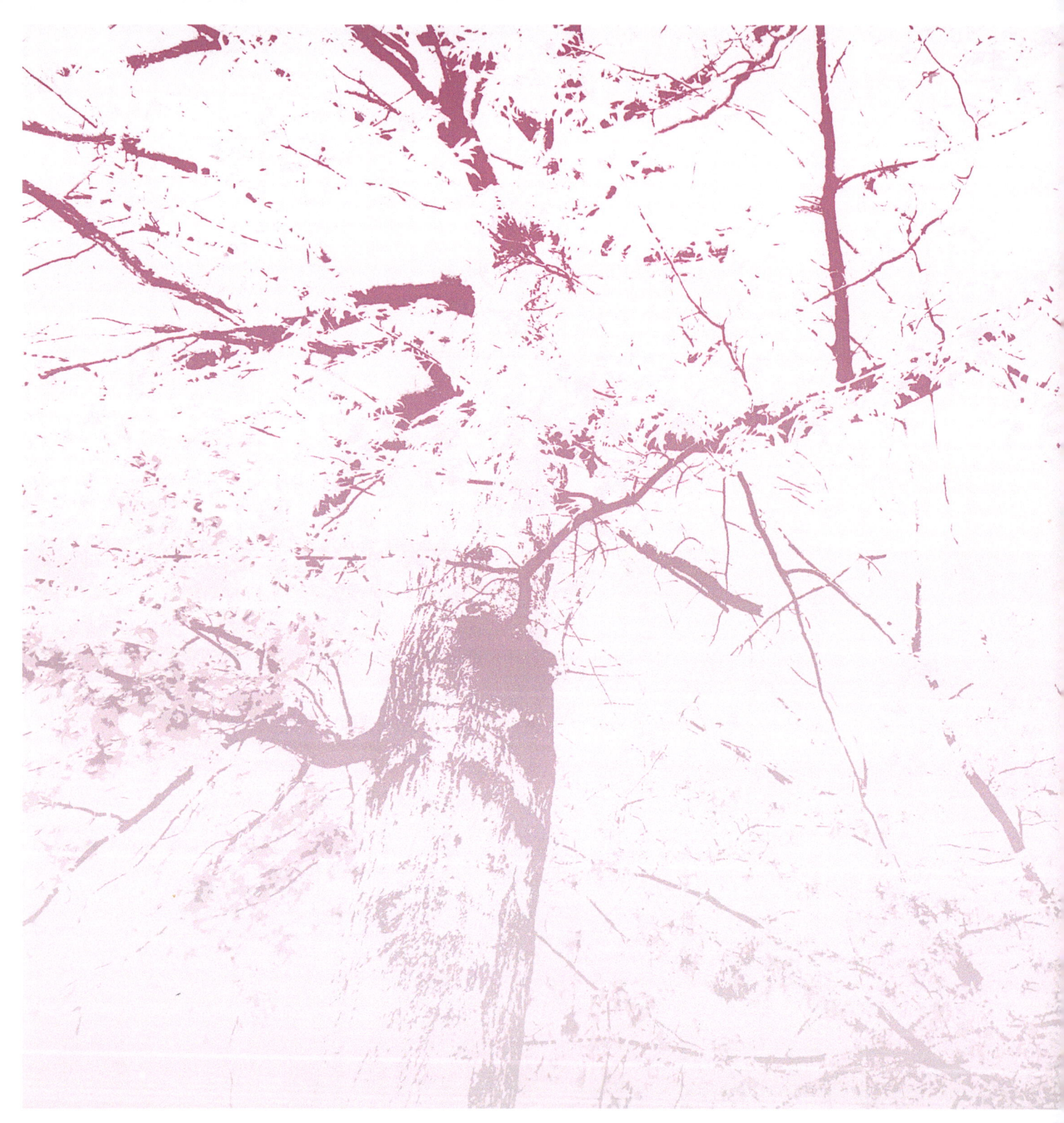

green
white

blue
white
purple

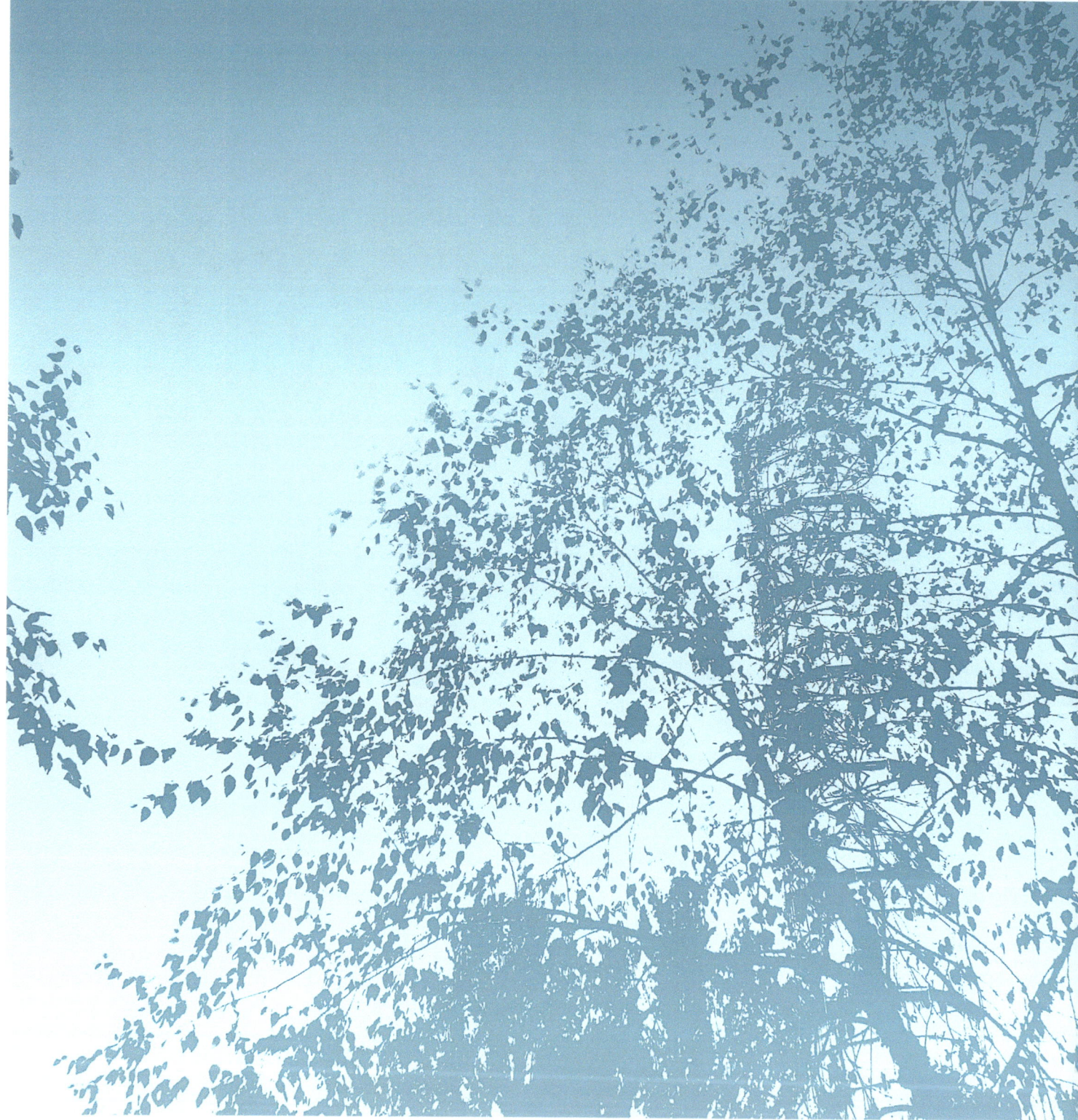

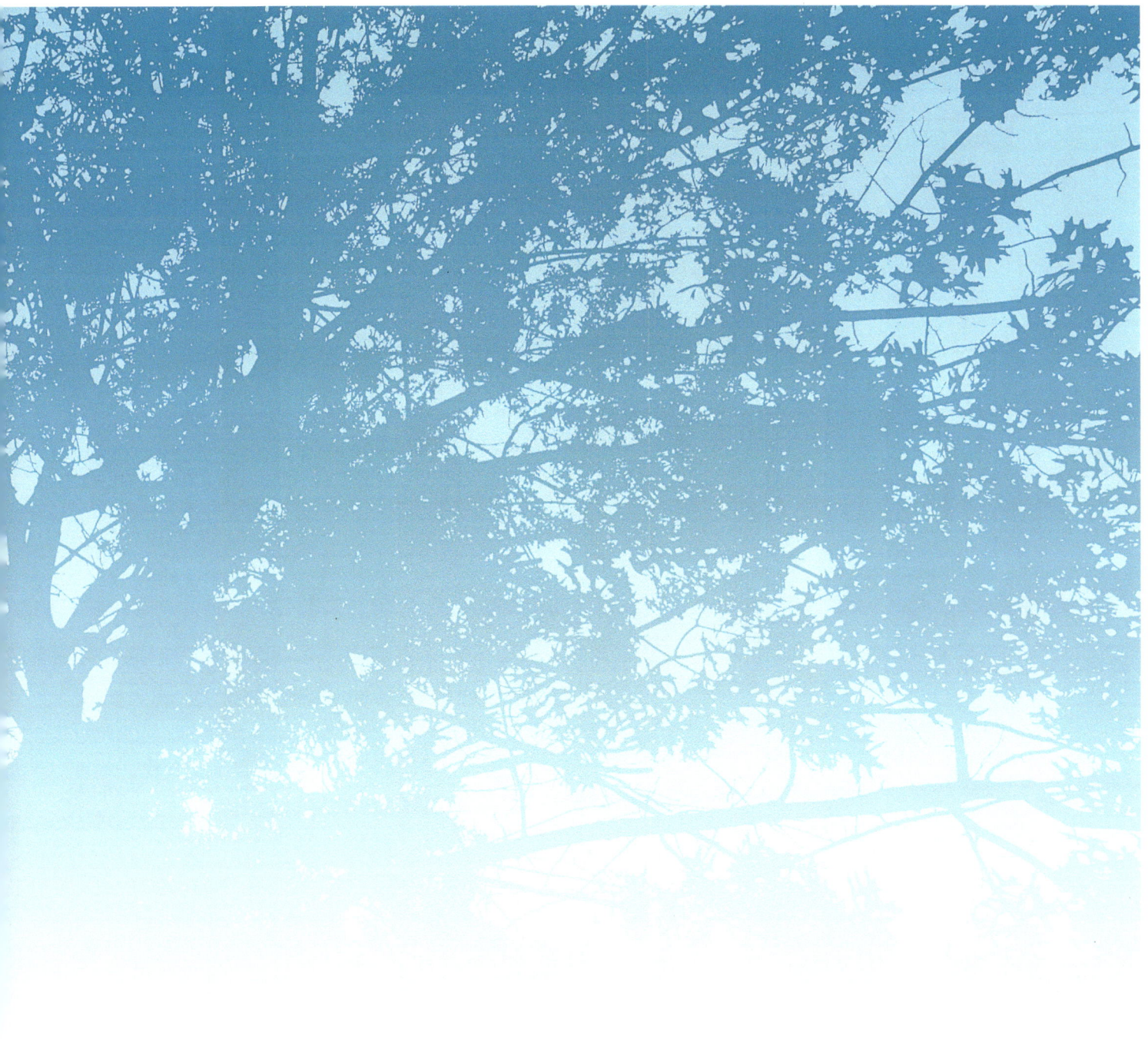

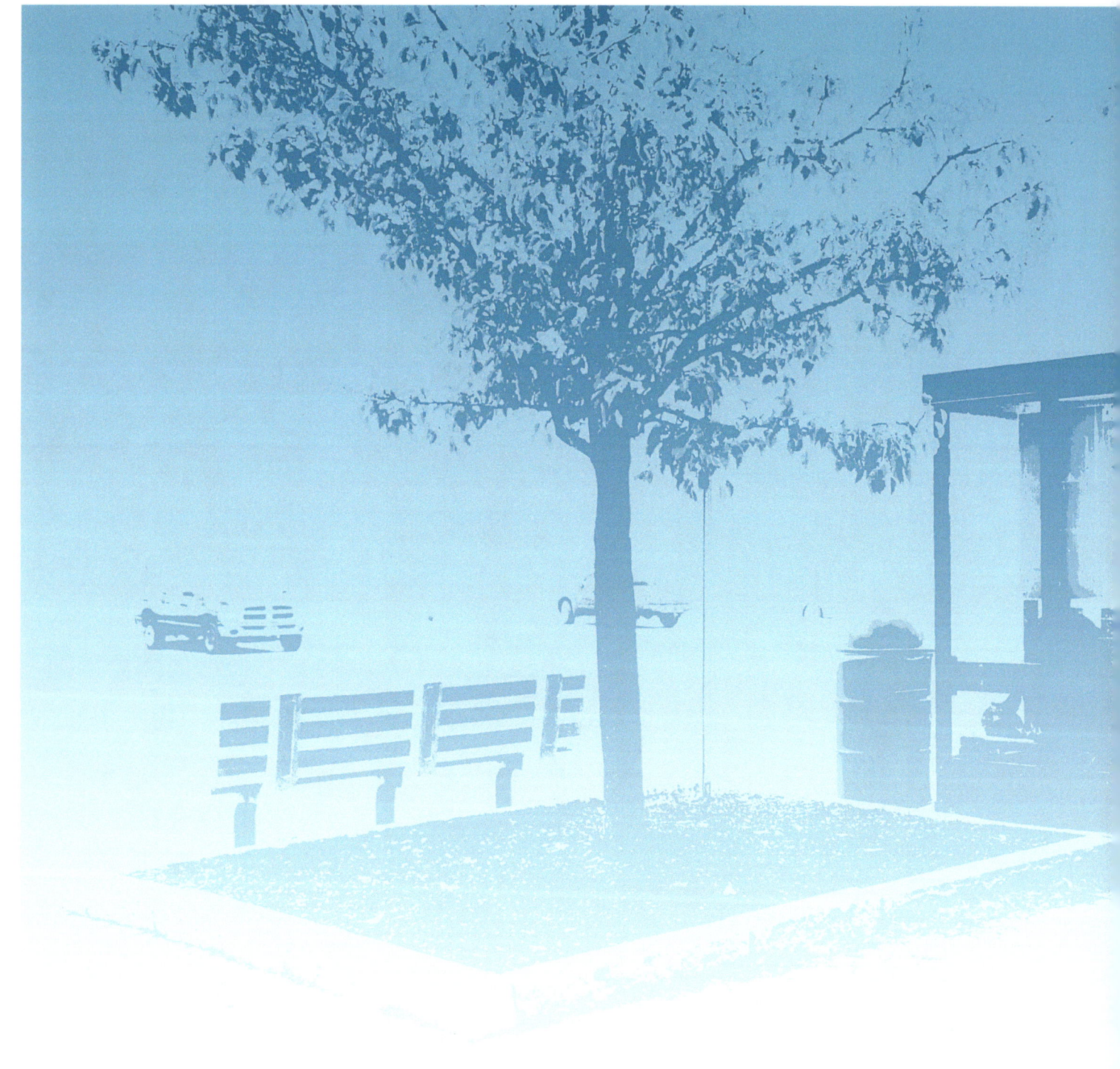

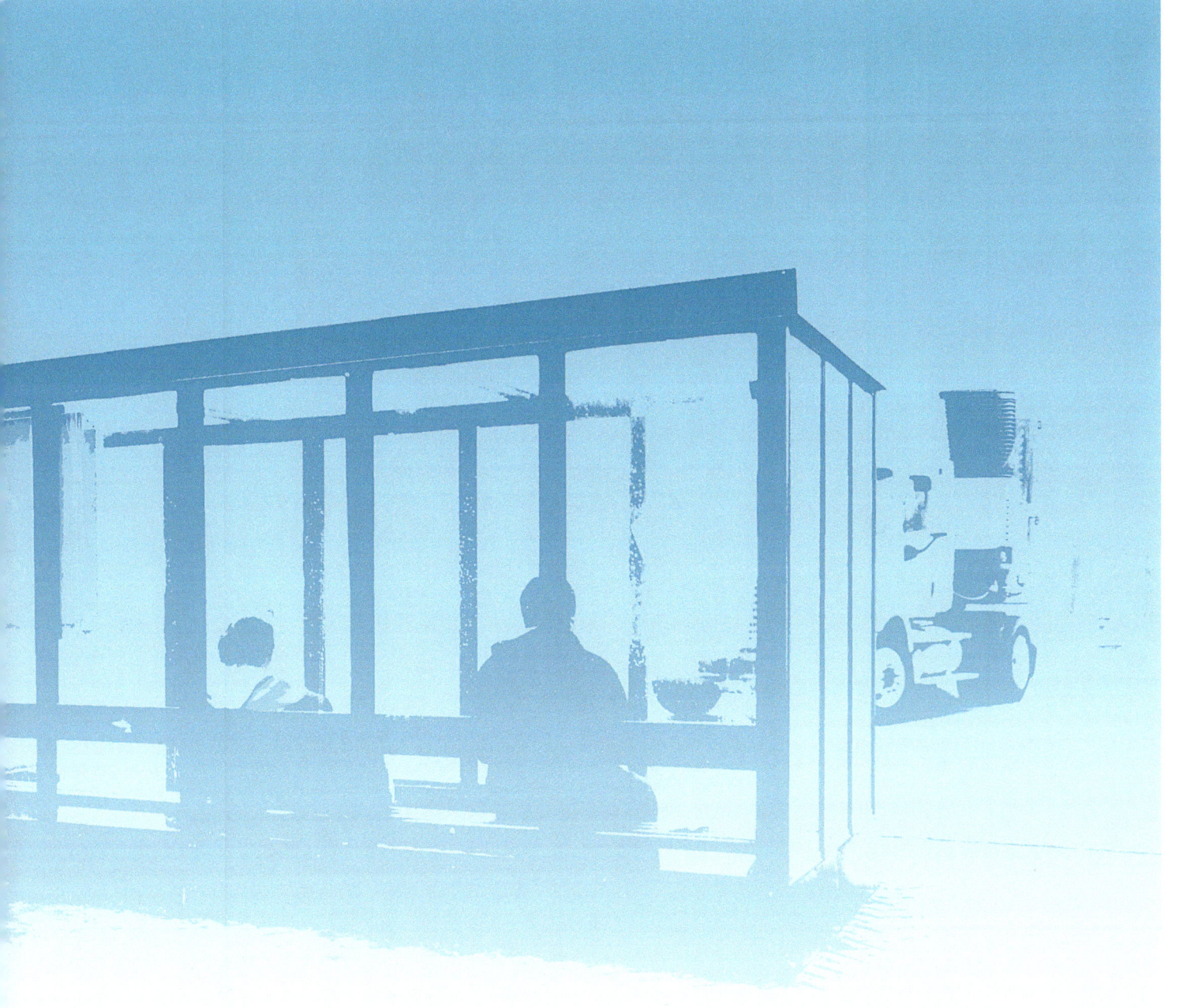

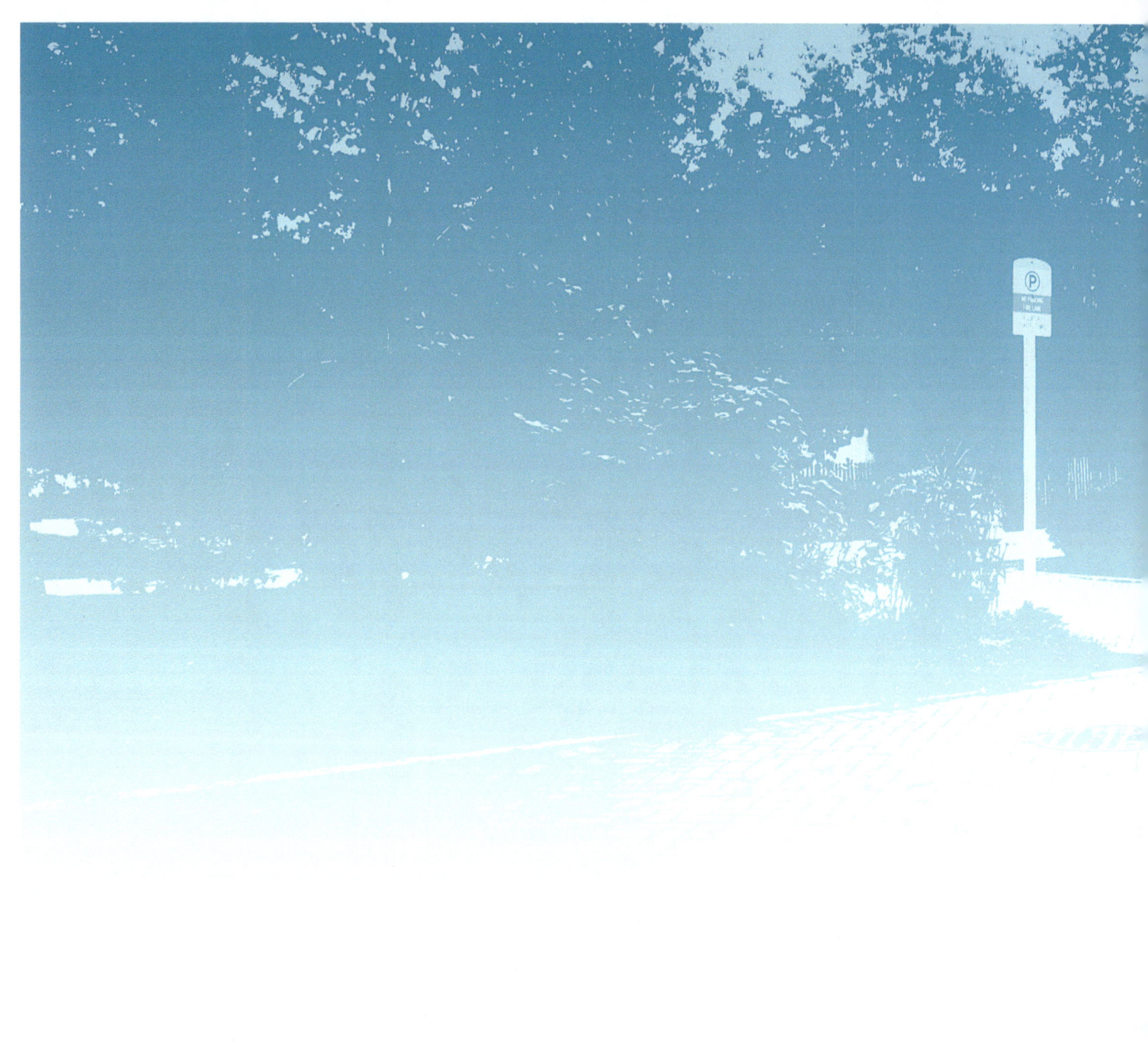

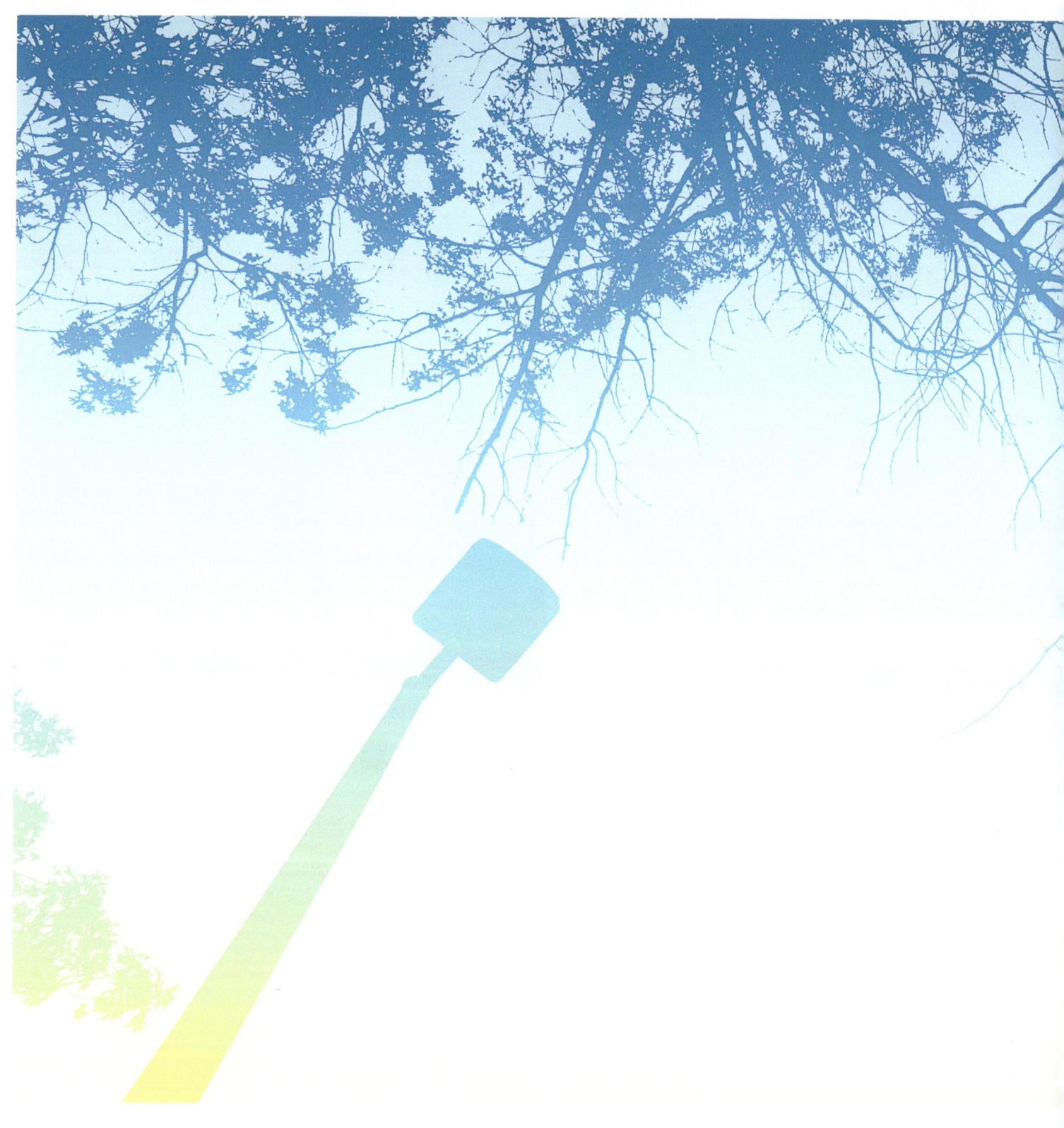

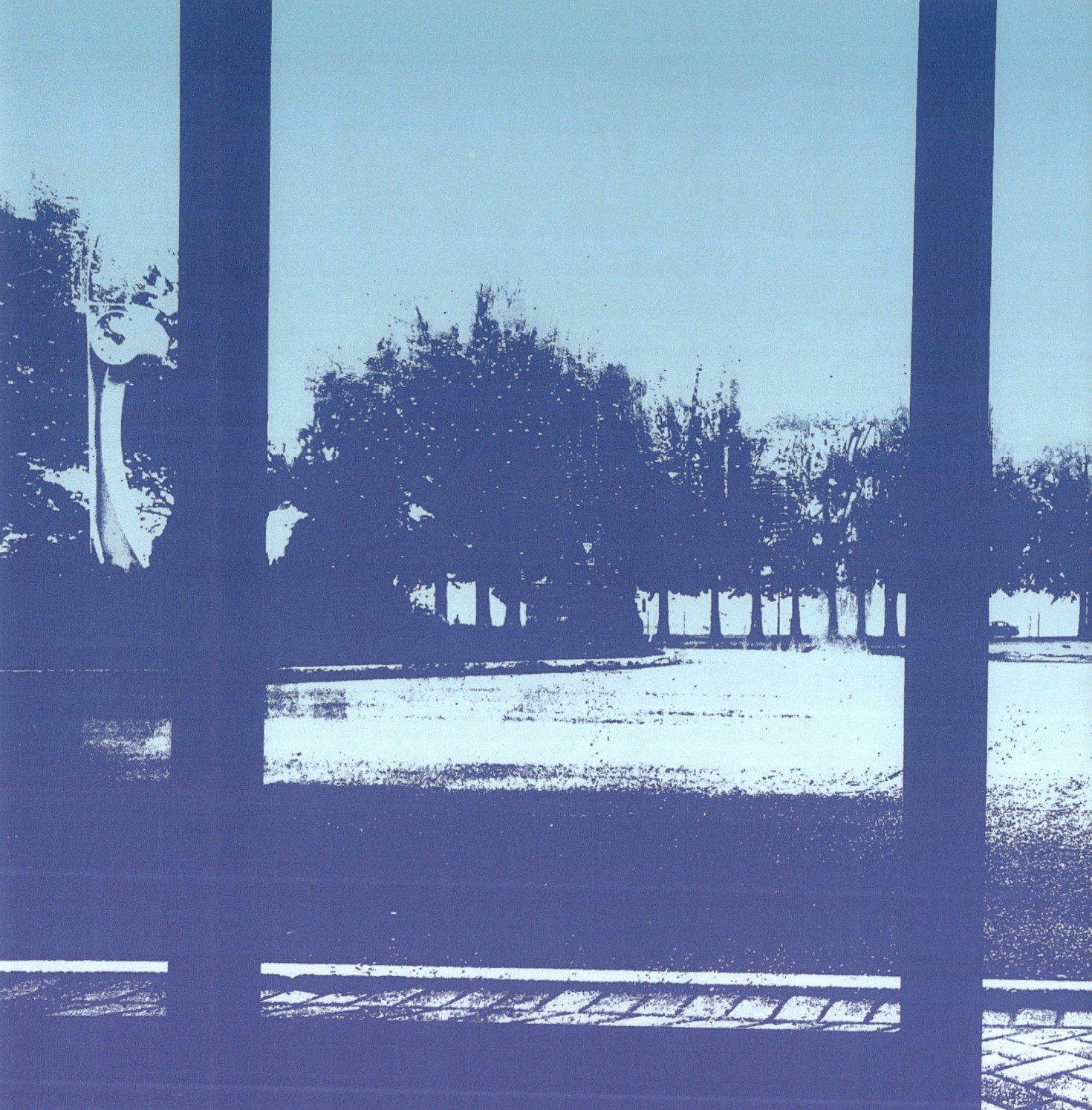

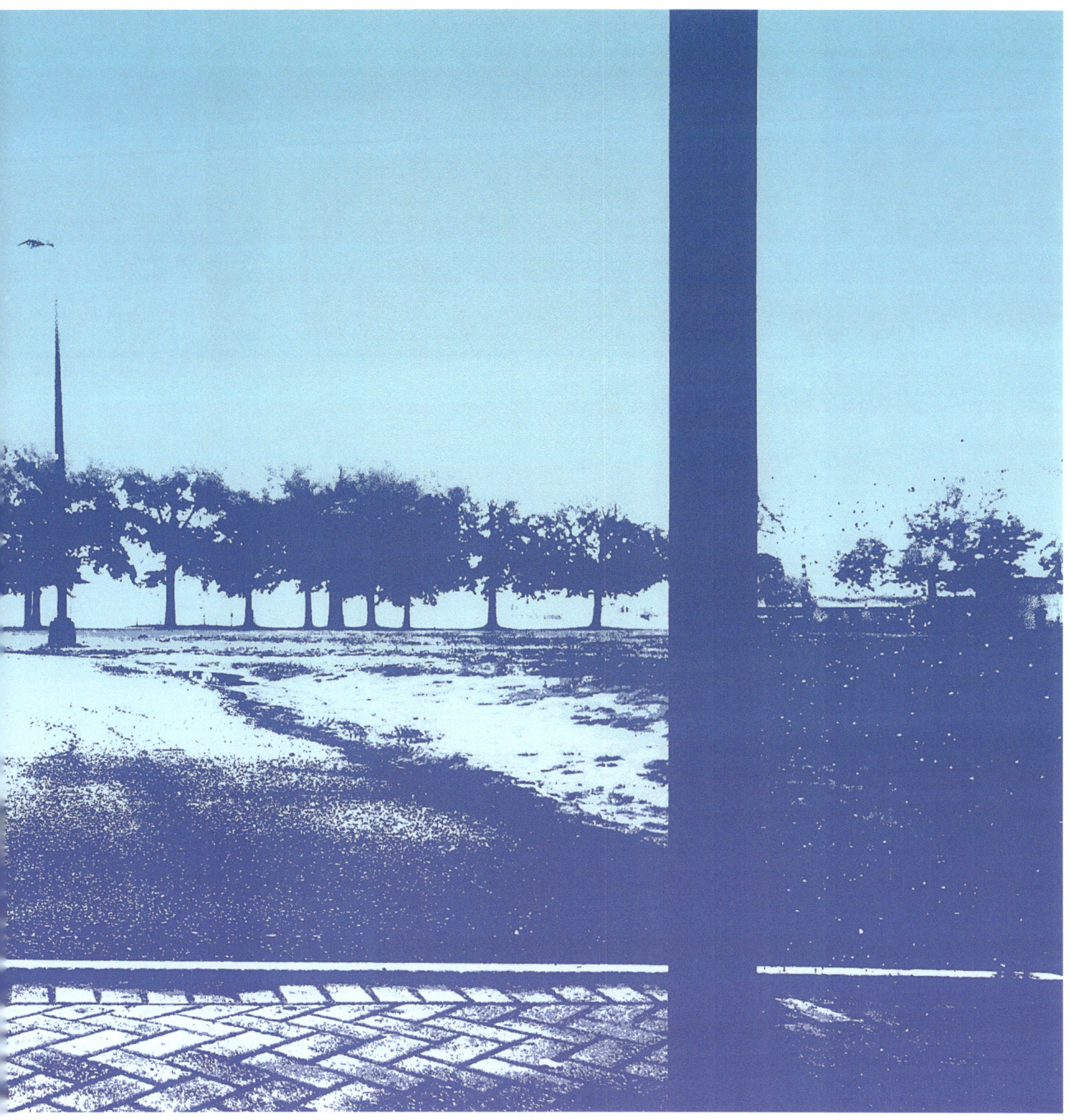

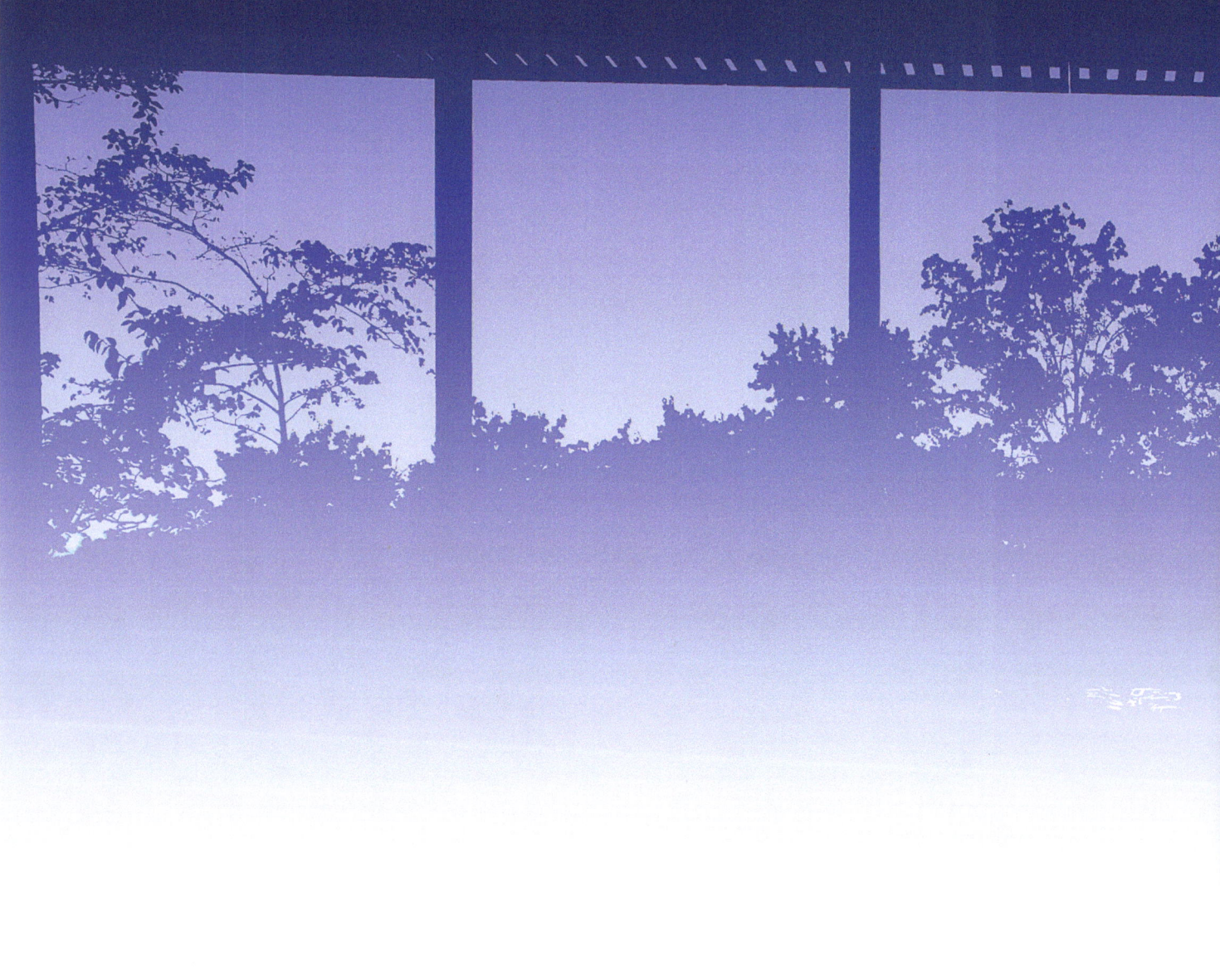

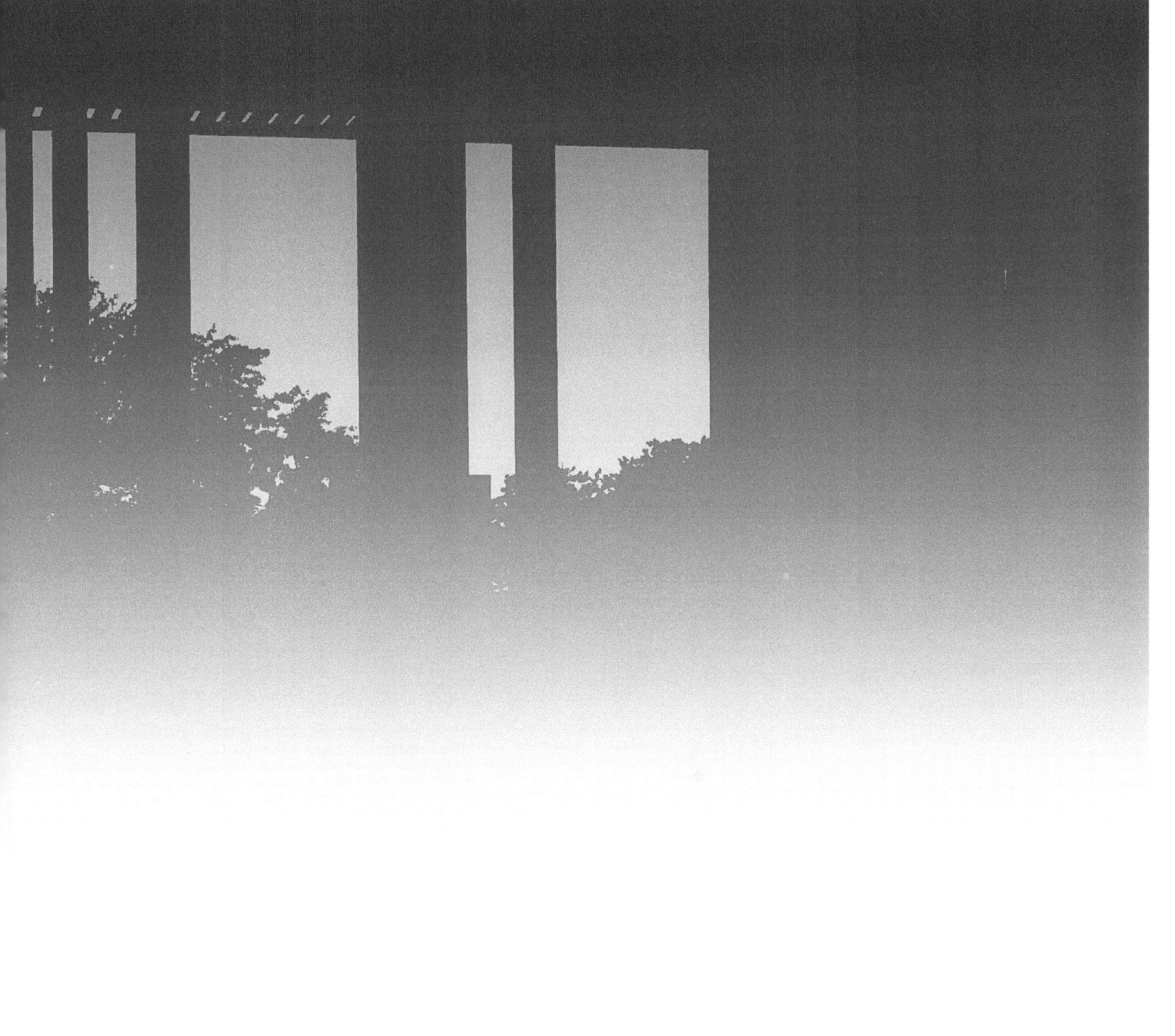

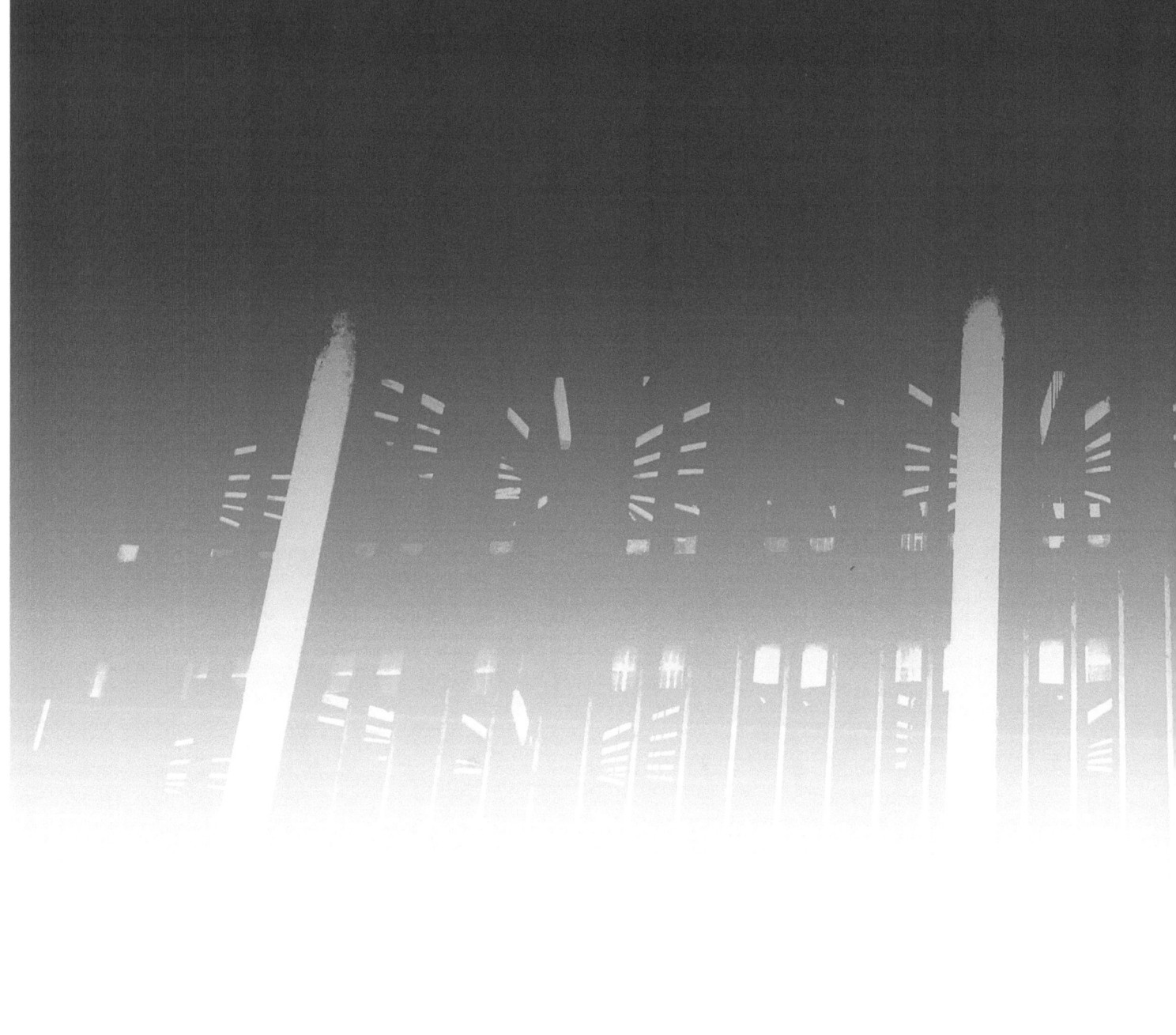

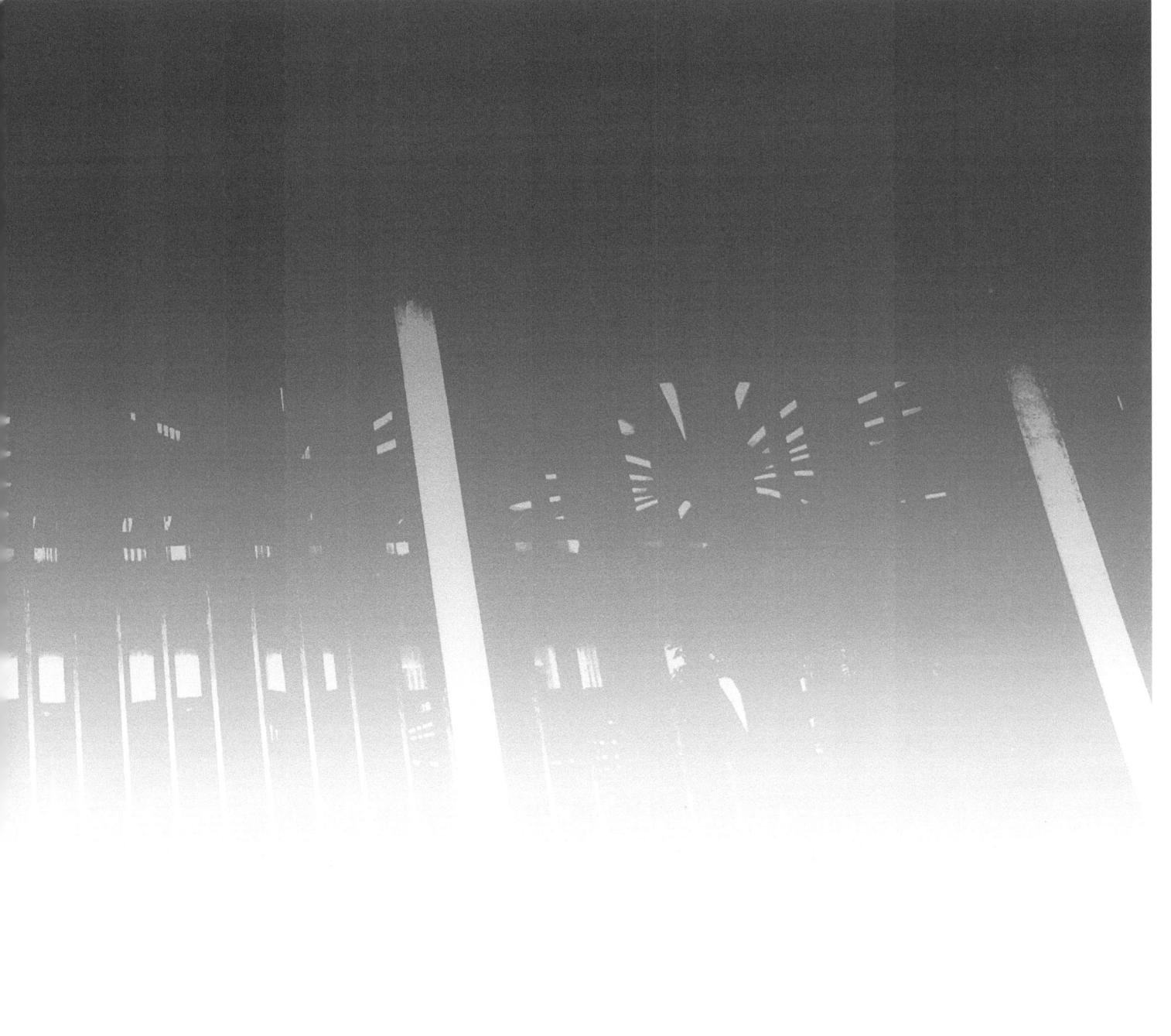

sonnet |ˈsänit|
noun
a poem of fourteen lines using any of a number of formal rhyme schemes,
in English typically having ten syllables per line.
verb (-neted, -neting) [intrans.] archaic
compose sonnets

Authors note:

IIn a poetry, color and shape are often embodied in rhyming and harmonius words.
In this photo series, I explore the possibility to convey harmony
in every picture as an attempt to depict William Shakespeare's sonnet about beauty.
Each of them illustrates an image surrounds my current reality: my life here in Albany, New York.

Widarto Adi, 2012

Photographer	: Widarto Adi
Location	: State University New York at Albany (SUNY Albany)
	Uptown Campus
	Albany, New York State Capital
for Print Art	: http://society6.com/dartovisualpoetry
for Digital Art	: http://500px.com/darto/sets/sonnet
contact	: email.visual.poetry@gmail.com

1609 Quarto Version

VNthrifty louelineſſe why doſt thou ſpend,
Vpon thy ſelfe thy beauties legacy?

Natures bequeſt giues nothing but doth lend,
And being franck ſhe lends to thoſe are free:

Then beautious nigard why dooſt thou abuſe,
The bountious largeſſe giuen thee to giue?

Profitles vſerer why dooſt thou vſe
So great a ſumme of ſummes yet can'ſt not liue?

For hauing traffike with thy ſelfe alone,
Thou of thy ſelfe thy ſweet ſelfe doſt deceaue,

Then how when nature calls thee to be gone,
What acceptable Audit can'ſt thou leaue?

Thy vnuſ'd beauty muſt be tomb'd with thee,
Which vſed liues th'executor to be

Unthrifty loveliness, why dost thou spend
Upon thy self thy beauty's legacy?

Nature's bequest gives nothing, but doth lend,
And being frank she lends to those are free:

Then, beauteous niggard, why dost thou abuse
The bounteous largess given thee to give?

Profitless usurer, why dost thou use
So great a sum of sums, yet canst not live?

For having traffic with thy self alone,
Thou of thy self thy sweet self dost deceive:

Then how when nature calls thee to be gone,
What acceptable audit canst thou leave?

Thy unused beauty must be tombed with thee,
Which, used, lives th' executor to be

William Shakespeare

www.ingramcontent.com/pod-product-compliance
Lightning Source LLC
Chambersburg PA
CBHW050406180526
45159CB00005B/2173